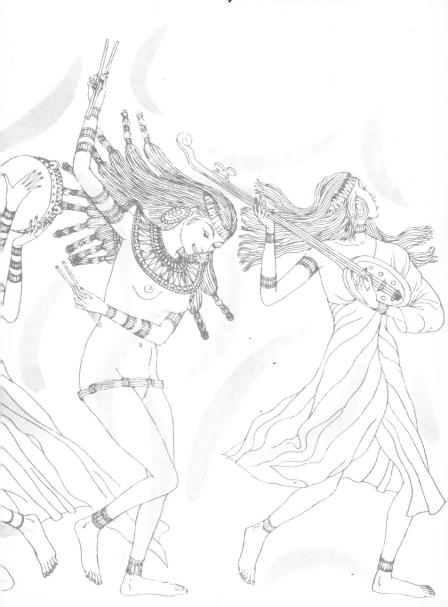

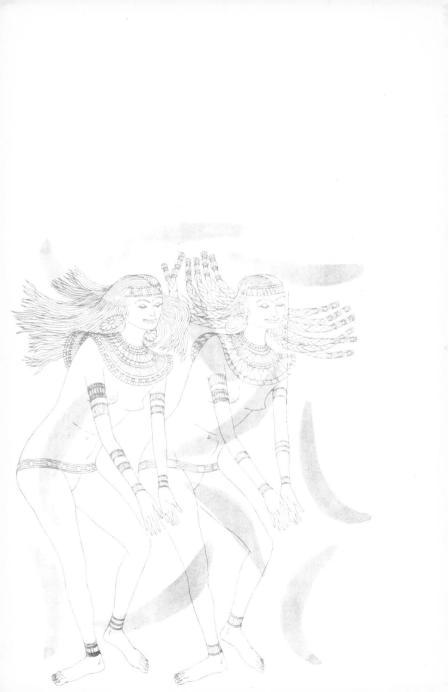

THE SONG OF SOLOMON

Idea and concept, copyright © 1968:
by Tre Tryckare, Cagner & Co, Gothenburg, Sweden
Text: The Authorised Version of the King James Bible
Illustrations: Ake Gustavsson
Publishers: Simon and Schuster, Rockefeller Center,
630 Fifth Avenue, New York, N.Y. 10020
Printed in Italy
Library of Congress Catalog Card Number: 68-55024

THE SONG OF SOLOMON

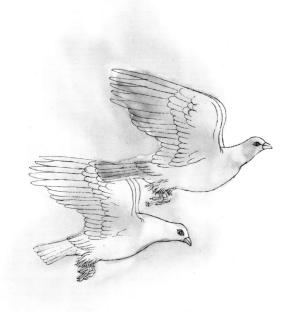

SIMON AND SCHUSTER

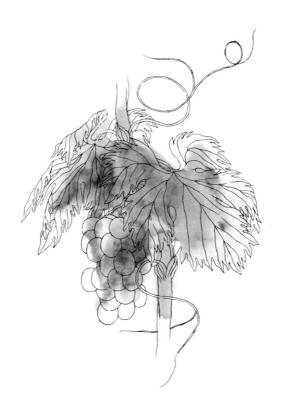

"for love is strong as death; jealousy is cruel as the grave: the coals thereof are coals of fire,..."

Chapter 8, verse 6

CHAPTER 1
The Bride's Converse with her Lord

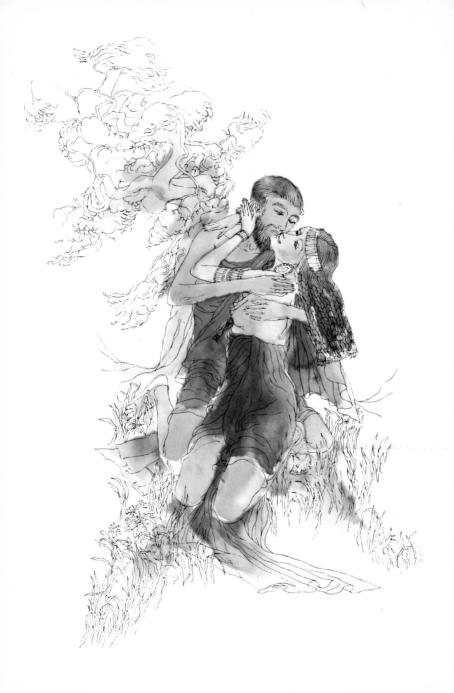

The song of songs, which is Solomon's.

Let him kiss me with the kisses of his mouth: for thy love is better than wine.

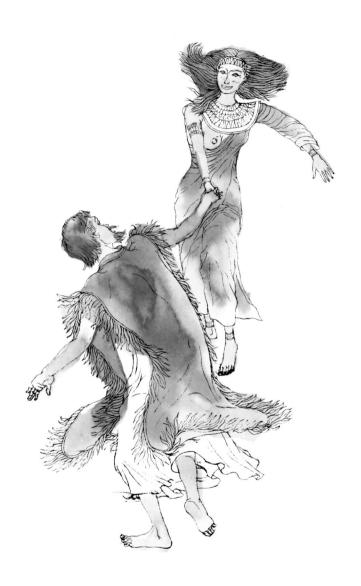

Because of the savour of thy good ointments thy name *is as* ointment poured forth, therefore do the virgins love thee.

4

Draw me, we will run after thee:
the king hath brought me into his chambers:
we will be glad and rejoice in thee,
we will remember thy love more than wine:
the upright love thee.

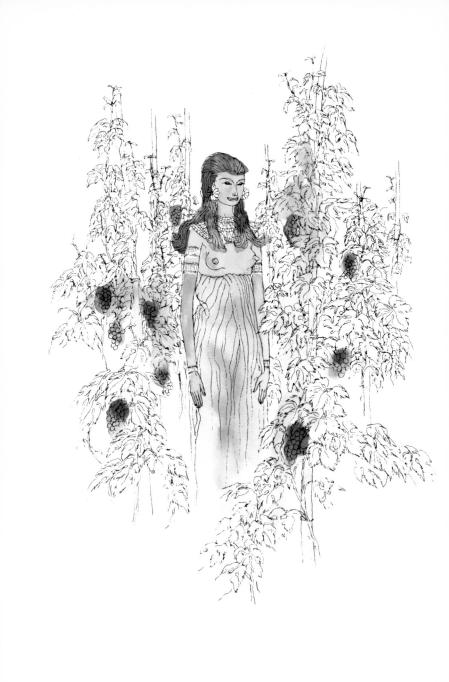

I am black, but comely,
O ye daughters of Jerusalem,
as the tents of Kedar,
as the curtains of Solomon.

6

Look not upon me, because I am black, because the sun hath looked upon me: my mother's children were angry with me; they made me the keeper of the vineyards; but mine own vineyard have I not kept.

Tell me, O thou whom my soul loveth,
where thou feedest,
where thou makest thy flock to rest at noon:
for why should I be as one that turneth aside
by the flocks of thy companions?

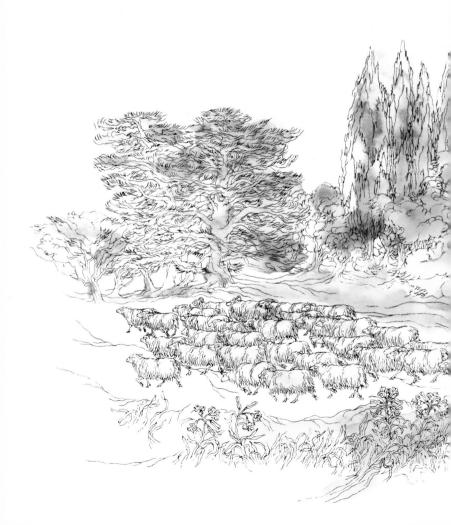

If thou know not, O thou fairest among women, go thy way forth by the footsteps of the flock, and feed thy kids beside the shepherds' tents.

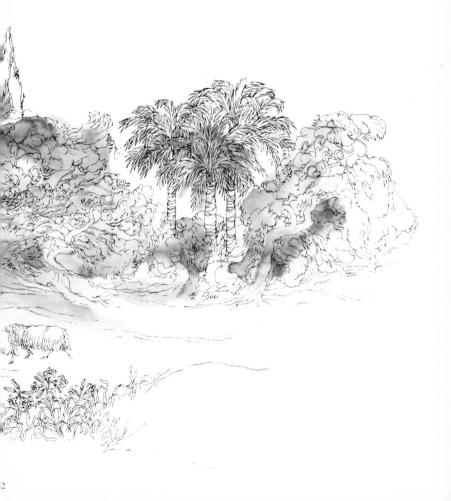

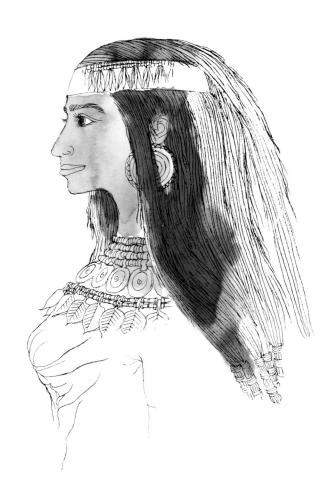

I have compared thee, O my love, to a company of horses in Pharaoh's chariots.

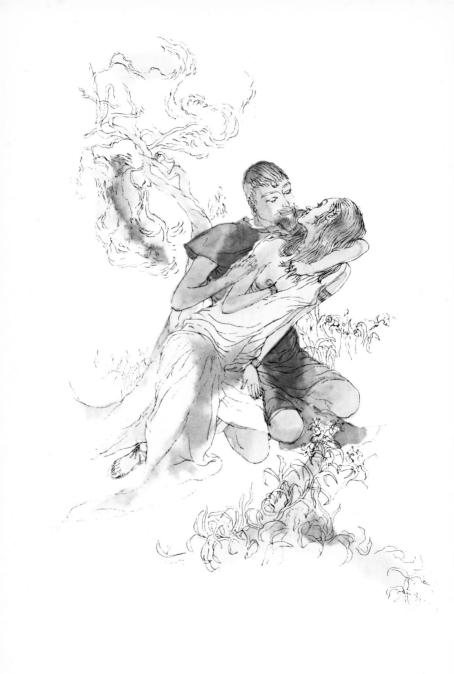

Thy cheeks are comely with rows of jewels, thy neck with chains of gold.

11

We will make thee borders of gold with studs of silver.

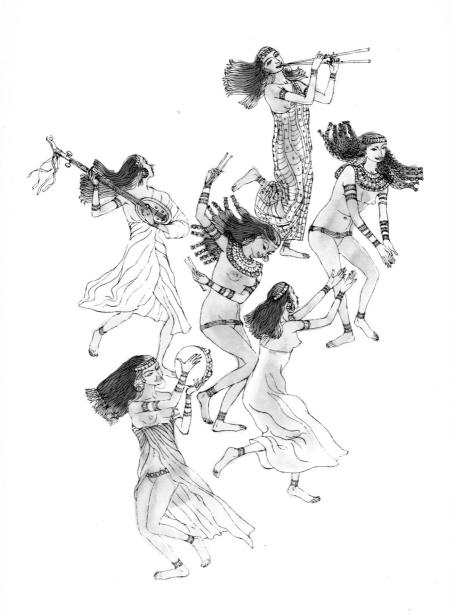

While the king *sitteth* at his table, my spikenard sendeth forth the smell thereof.

13

A bundle of myrrh *is* my well-beloved unto me; he shall lie all night betwixt my breasts.

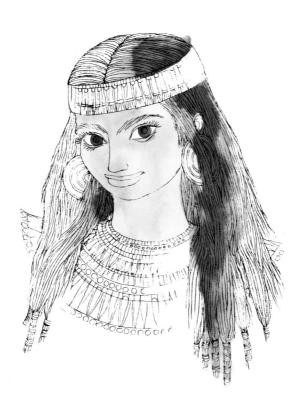

My beloved *is* unto me *as* a cluster of camphire in the vineyards of Engedi.

15

Behold, thou art fair, my love; behold, thou art fair; thou hast doves' eyes

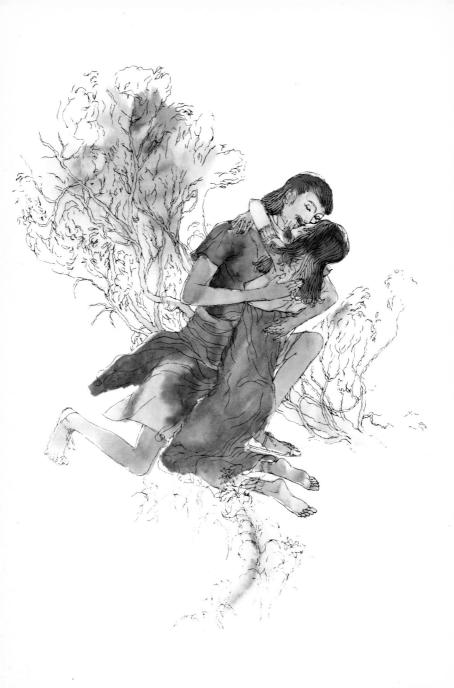

16
Behold, thou *art* fair,
my beloved, yea, pleasant:
also our bed *is* green.

The beams of our house *are* cedar, and our rafters of fir.

CHAPTER 2
The Bridegroom's Love

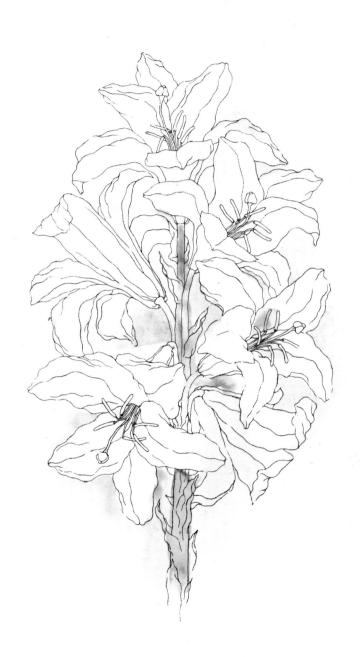

I am the rose of Sharon, and the lily of the valleys.

2

As the lily among thorns, so *is* my love among the daughters.

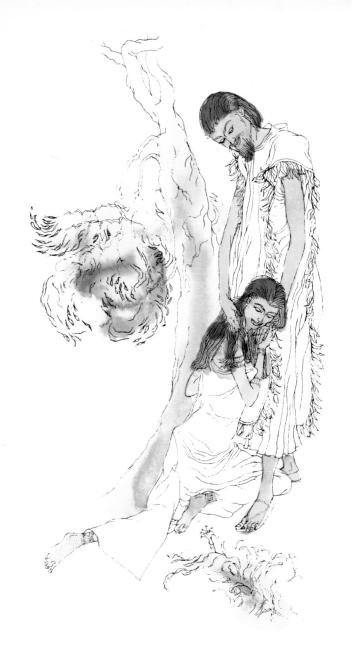

As the apple tree among the trees of the wood, so *is* my beloved among the sons.

I sat down under his shadow with great delight, and his fruit *was* sweet to my taste.

He brought me to the banqueting house, and his banner over me was love.

5
Stay me with flagons, comfort me with apples:
for I am sick of love.

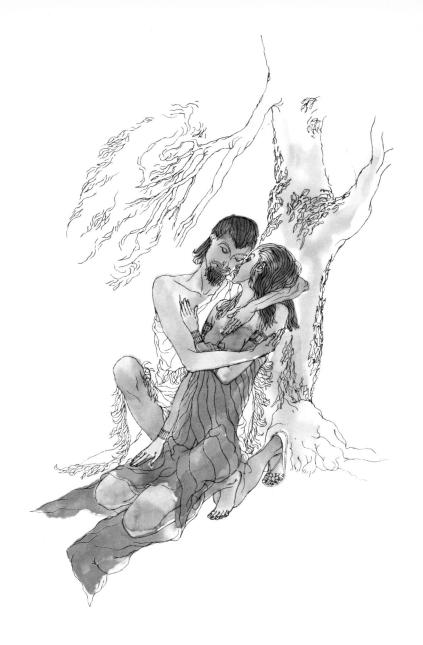

His left hand is under my head, and his right hand doth embrace me.

7

I charge you, O ye daughters of Jerusalem, by the roes, and by the hinds of the field, that ye stir not up, nor awake *my* love, till he please.

8

The voice of my beloved! behold, he cometh leaping upon the mountains, skipping upon the hills.

My beloved is like a roe or a young hart: behold, he standeth behind our wall, he looketh forth at the windows, shewing himself through the lattice.

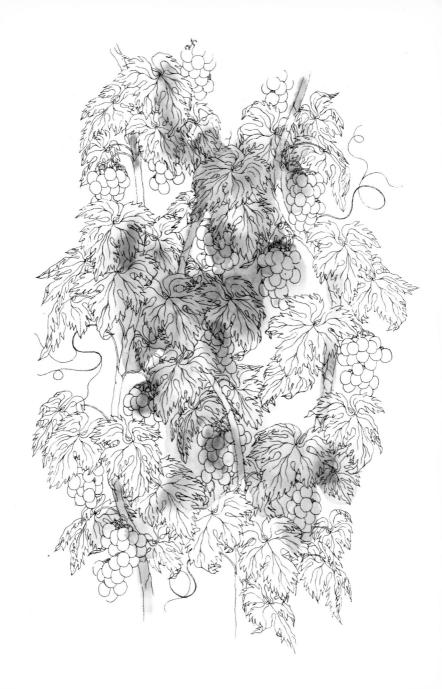

My beloved spake, and said unto me, Rise up, my love, my fair one, and come away.

11

For, lo, the winter is past, the rain is over and gone;

12

The flowers appear on the earth; the time of the singing *of birds* is come, and the voice of the turtle is heard in our land;

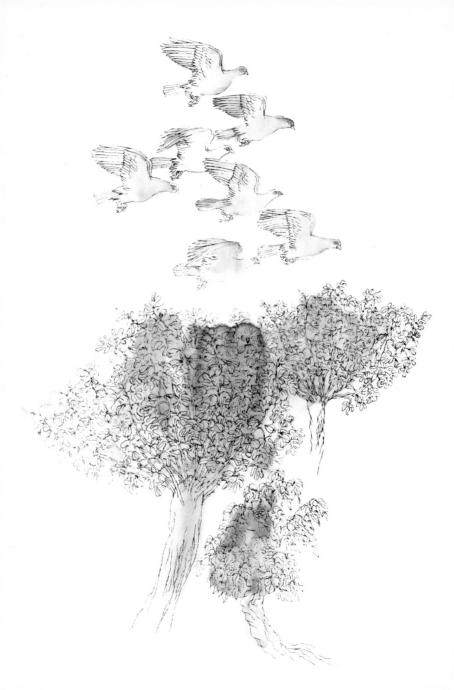

The fig tree putteth forth her green figs, and the vines with the tender grape give a good smell. Arise, my love, my fair one, and come away.

14

O my dove, *that art* in the clefts of the rock, in the secret *places* of the stairs, let me see thy countenance, let me hear thy voice; for sweet *is* thy voice, and thy countenance *is* comely.

15

Take us the foxes, the little foxes, that spoil the vines: for our vines *have* tender grapes.

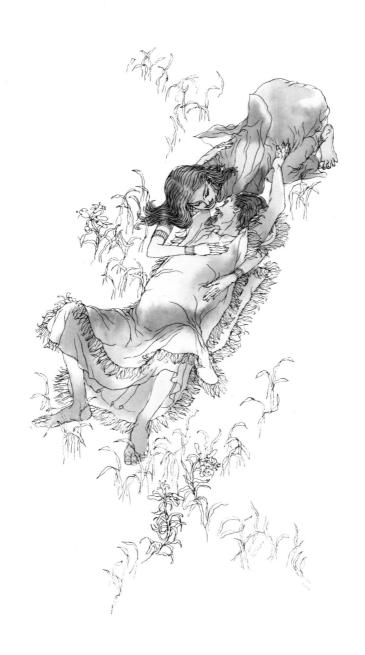

My beloved *is* mine, and I *am* his: he feedeth among the lilies.

Until the day break, and the shadows flee away, turn, my beloved, and be thou like a roe or a young hart upon the mountains of Bether.

CHAPTER 3
The Bride's Dream; her Lord's Glory

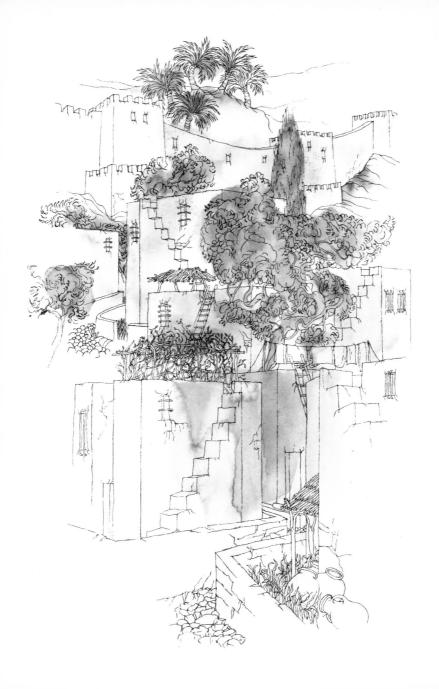

By night on my bed I sought him whom my soul loveth:
I sought him, but I found him not.

2

I will rise now,
and go about the city in the streets,
and in the broad ways I will seek him
whom my soul loveth:
I sought him, but I found him not.

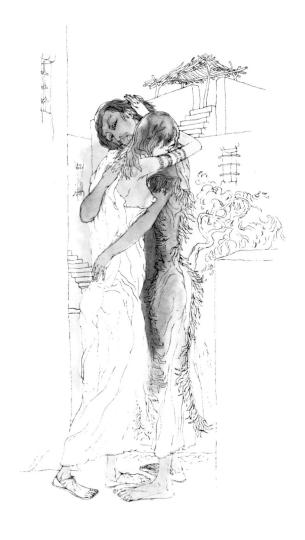

The watchmen that go about the city found me:
to whom I said,

Saw ye him whom my soul loveth?

4

It was but a little that I passed from them, but I found him whom my soul loveth:
I held him, and would not let him go, until I had brought him into my mother's house, and into the chamber of her that conceived me.

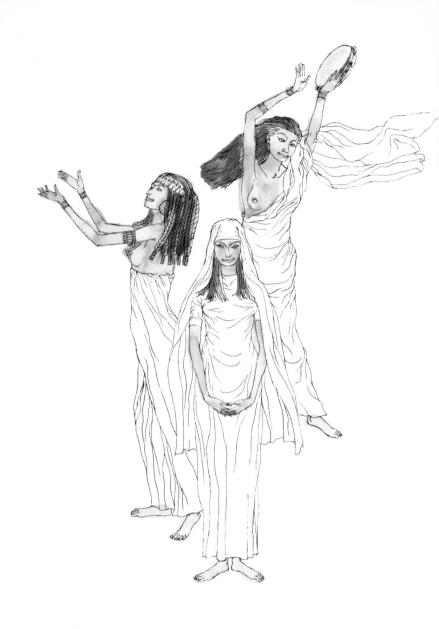

I charge you, O ye daughters of Jerusalem, by the roes, and by the hinds of the field, that ye stir not up, nor awake *my* love, till he please.

Who *is* this that cometh out of the wilderness like pillars of smoke, perfumed with myrrh and frankincense, with all powders of the merchant?

7
Behold his bed, which is Solomon's; threescore valiant men are about it, of the valiant of Israel.

They all hold swords, *being* expert in war: every man *hath* his sword upon his thigh because of fear in the night.

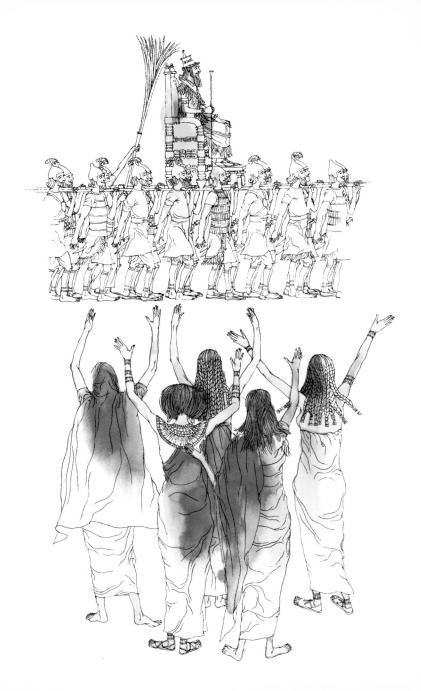

King Solomon made himself a chariot of the wood of Lebanon.

10

He made the pillars thereof of silver, the bottom thereof of gold, the covering of it of purple, the midst thereof being paved with love, for the daughters of Jerusalem.

Go forth, O ye daughters of Zion, and behold King Solomon with the crown wherewith his mother crowned him in the day of his espousals, and in the day of the gladness of his heart.

CHAPTER 4
The Bride's Plea to her Lord

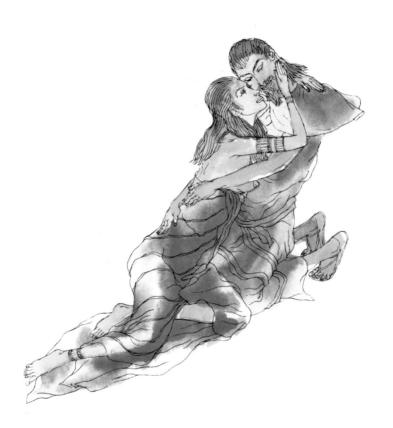

Behold, thou *art* fair, my love; behold, thou *art* fair; thou *hast* doves' eyes within thy locks: thy hair *is* as a flock of goats, that appear from mount Gilead.

Thy teeth *are* like a flock *of sheep*that are even shorn,
which came up from the washing;
whereof every one bears twins,
and none is barren among them.

3

Thy lips *are* like a thread of scarlet, and thy speech *is* comely: thy temples *are* like a piece of pomegranate within thy locks.

Thy neck is like the tower of David builded for an armoury, whereon there hang a thousand bucklers, all shields of mighty men.

5

Thy two breasts *are* like two young roes that are twins, which feed among the lilies.

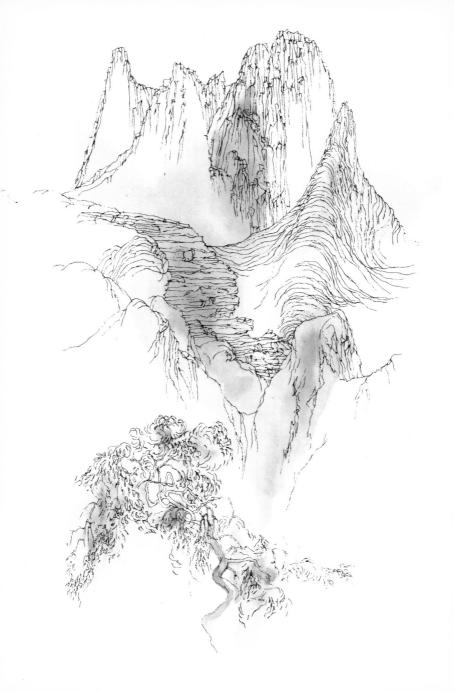

Until the day break, and the shadows flee away,
I will get me to the mountain of myrrh,
and to the hill of frankincense.

7
Thou *art* all fair, my love; *there is* no spot in thee.

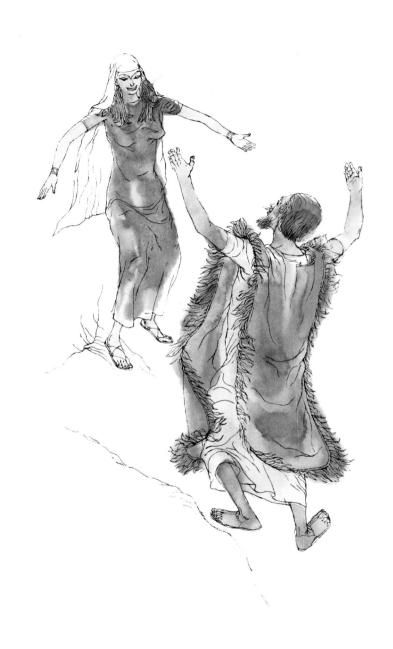

Come with me from Lebanon,

my spouse, with me from Lebanon:
look from the top of Amana,
from the top of Shenir and Hermon,
from the lions' dens,
from the mountains of the leopards.

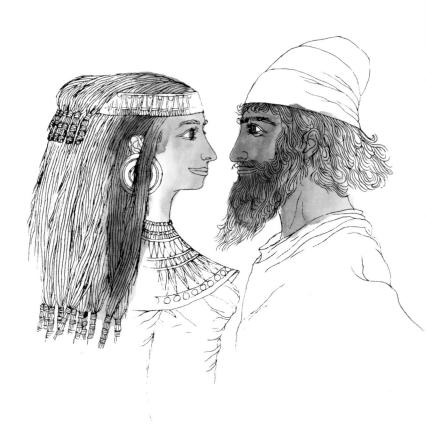

Thou hast ravished my heart, my sister, my spouse; thou hast ravished my heart with one of thine eyes, with one chain of thy neck.

10

How fair is thy love, my sister, my spouse! how much better is thy love than wine! and the smell of thine ointments than all spices!

Thy lips, O *my* spouse, drop *as* the honeycomb: honey and milk *are* under thy tongue; and the smell of thy garments *is* like the smell of Lebanon.

12

A garden inclosed *is* my sister, *my* spouse; a spring shut up, a fountain sealed.

Thy plants *are* an orchard of pomegranates, with pleasant fruits; camphire, with spikenard,

14

Spikenard and saffron; calamus and cinnamon, with all trees of frankincense; myrrh and aloes, with all the chief spices:

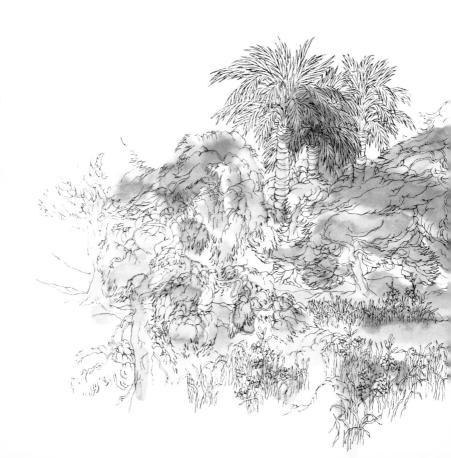

A fountain of gardens, a well of living waters, and streams from Lebanon.

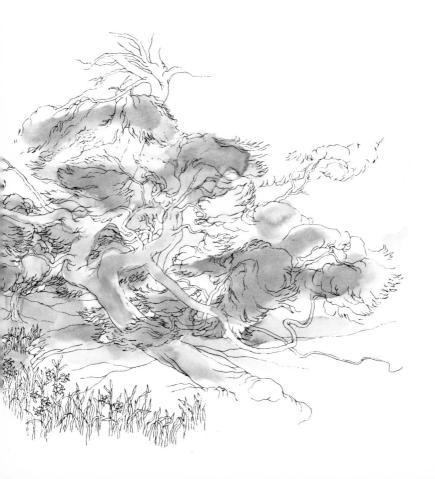

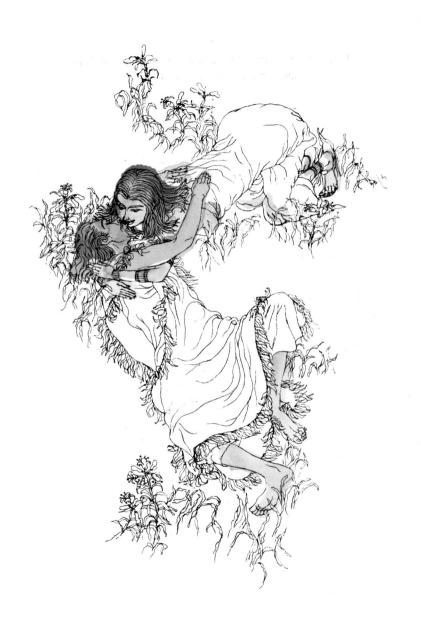

Awake, O north wind; and come, thou south; blow upon my garden, that the spices thereof may flow out.

Let my beloved come into his garden, and eat his pleasant fruits.

CHAPTER 5
The Bride's Dream of Separation

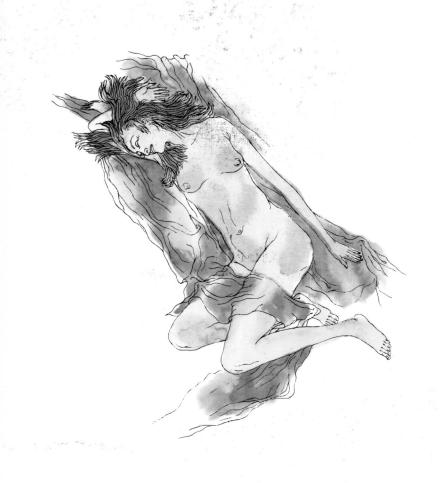

(· . .

I am come into my garden, my sister, my spouse:

I have gathered my myrrh with my spice;
I have eaten my honeycomb with my honey;
I have drunk my wine with my milk:
eat, O friends; drink, yea, drink abundantly,
O beloved.

2

I sleep, but my heart waketh:

it is the voice of my beloved that knocketh, saying,

Open to me, my sister, my love,

my dove, my undefiled:

for my head is filled with dew,

and my locks with the drops of the night.

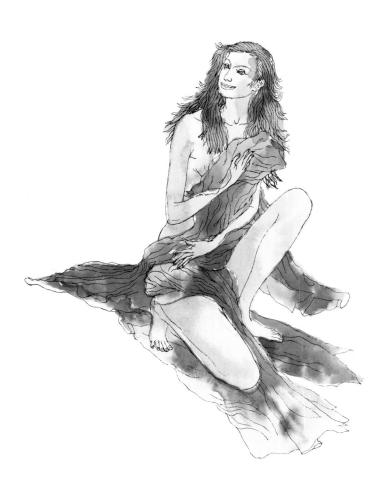

I have put off my coat; how shall I put it on? I have washed my feet; how shall I defile them?

4

My beloved put in his hand by the hole of the door, and my bowels were moved for him.

5

I rose up to open to my beloved; and my hands dropped with myrrh, and my fingers with sweet smelling myrrh, upon the handles of the lock.

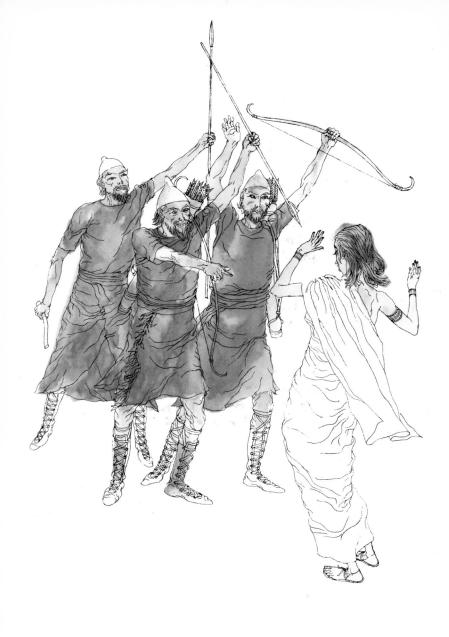

I opened to my beloved;
but my beloved had withdrawn himself,
and was gone:
my soul failed when he spake:
I sought him, but I could not find him;
I called him, but he gave me no answer.

7

The watchmen that went about the city found me, they smote me, they wounded me; the keepers of the walls took away my veil from me.

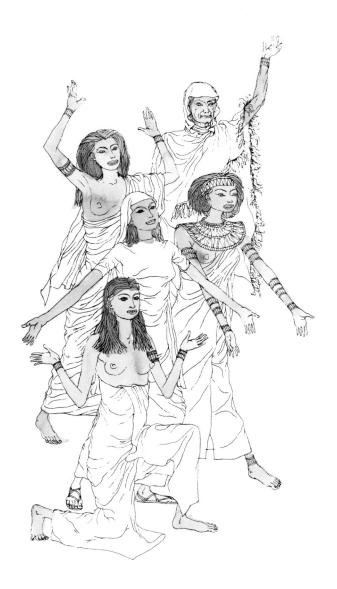

I charge you, O daughters of Jerusalem, if ye find my beloved, that ye tell him, that I am sick of love.

9

What is thy beloved more than another beloved,
O thou fairest among women?
what is thy beloved more than another beloved,
that thou dost so charge us?

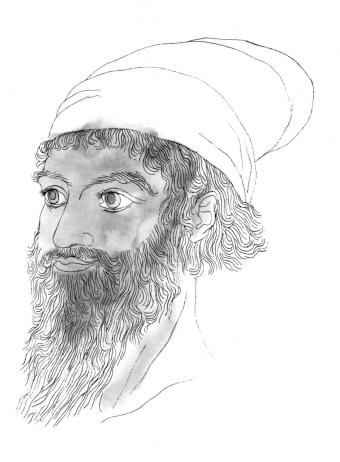

My beloved is white and ruddy, the chiefest among ten thousand.

11

His head is as the most fine gold, his locks are bushy, and black as a raven.

12

His eyes *are* as *the eyes* of doves by the rivers of waters, washed with milk, and fitly set.

13

His cheeks *are* as a bed of spices, *as* sweet flowers:

his lips *like* lilies,

dropping sweet smelling myrrh.

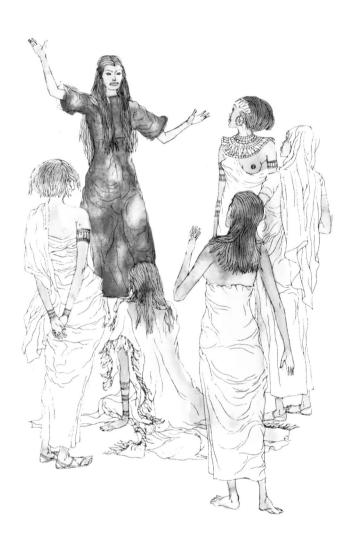

His hands *are as* gold rings set with the beryl: his belly *is as* bright ivory overlaid *with* sapphires.

15

His legs *are as* pillars of marble, set upon sockets of fine gold: his countenance *is* as Lebanon, excellent as the cedars.

His mouth *is* most sweet:
yea, he *is* altogether lovely.

This *is* my beloved, and this *is* my friend,
O daughters of Jerusalem.

CHAPTER 6
King Portrays Beauty of Bride

Whither is thy beloved gone, O thou fairest among women? whither is thy beloved turned aside? that we may seek him with thee.

2

My beloved is gone down into his garden, to the beds of spices, to feed in the gardens, and to gather lilies.

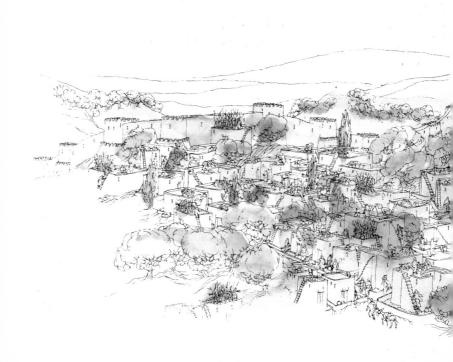

I am my beloved's, and my beloved is mine: he feedeth among the lilies.

4

Thou *art* beautiful, O my love, as Tirzah, comely as Jerusalem, terrible as *an army* with banners.

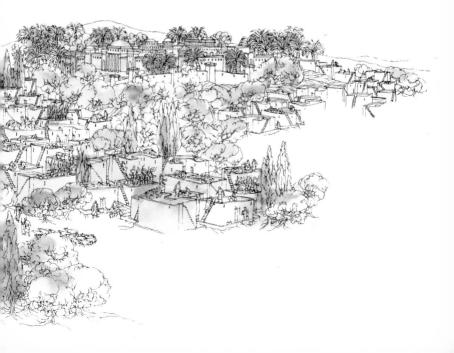

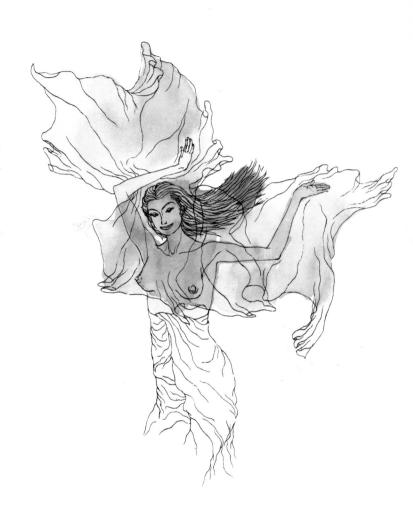

Turn away thine eyes from me, for they have overcome me: thy hair is as a flock of goats that appear from Gilead.

6

Thy teeth *are* as a flock of sheep which go up from the washing, whereof every one beareth twins, and *there is* not one barren among them.

7

As a piece of pomegranate *are* thy temples within thy locks.

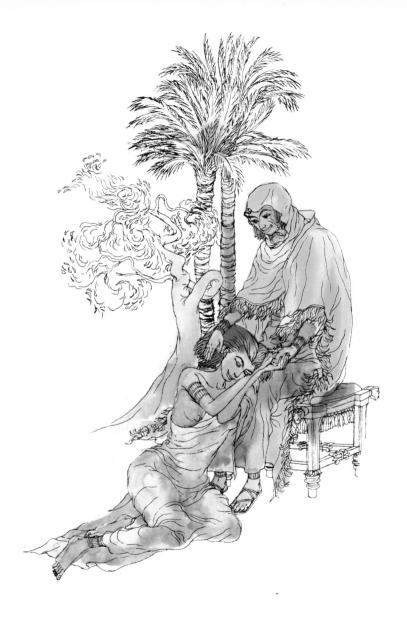

There are threescore queens, and fourscore concubines, and virgins without number.

9

My dove, my undefiled is *but* one; she *is* the *only* one of her mother, she *is* the choice *one* of her that bare her. The daughters saw her, and blessed her; *yea*, the queens and the concubines, and they praised her.

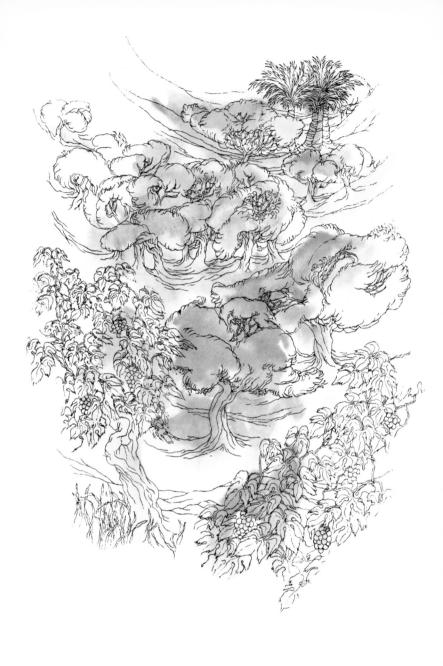

Who is she that looketh forth as the morning, fair as the moon, clear as the sun, and terrible as an army with banners?

11

I went down into the garden of nuts to see
the fruits of the valley,
and to see whether the vine flourished,
and the pomegranates budded.

12

Or ever I was aware, my soul made me *like* the chariots of Amminadib.

Return, return, O Shulamite; return, return, that we may look upon thee. What will ye see in the Shulamite? As it were the company of two armies.

CHAPTER 7
The Bride's Petition

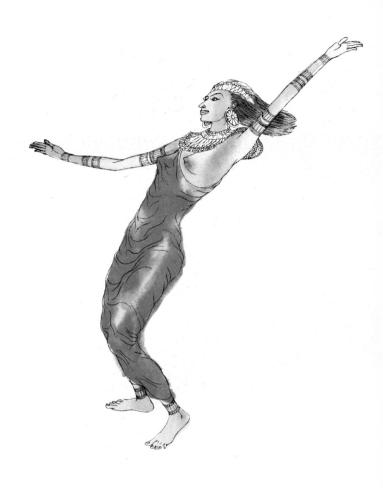

How beautiful are thy feet with shoes,
O prince's daughter!
the joints of thy thighs *are* like jewels,
the work of the hands of a cunning workman.

2

Thy navel is like a round goblet, which wanteth not liquor: thy belly is like an heap of wheat set about with lilies.

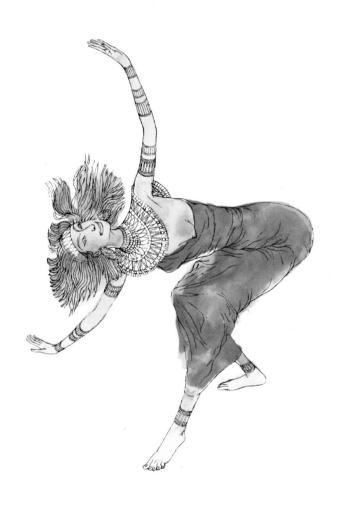

Thy two breasts *are* like two young roes that are twins.

4

Thy neck *is* as a tower of ivory; thine eyes *like* the fishpools in Heshbon, by the gate of Bath-rabbim: thy nose *is* as the tower of Lebanon which looketh toward Damascus.

5

Thine head upon thee *is* like Carmel, and the hair of thine head like purple; the king *is* held in the galleries.

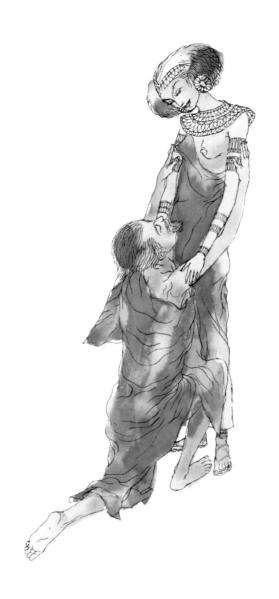

How fair and how pleasant art thou, O love, for delights!

7

This thy stature is like to a palm tree, and thy breasts to clusters of grapes.

8

I said, I will go up to the palm tree,
I will take hold of the boughs thereof:
now also thy breasts shall be as clusters of the vine,
and the smell of thy nose like apples;

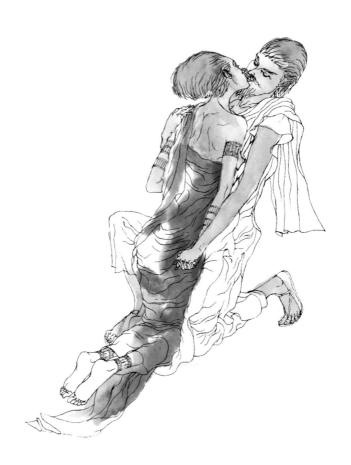

And the roof of thy mouth like the best wine for my beloved, that goeth down sweetly, causing the lips of those that are asleep to speak.

I am my beloved's, and his desire is toward me.

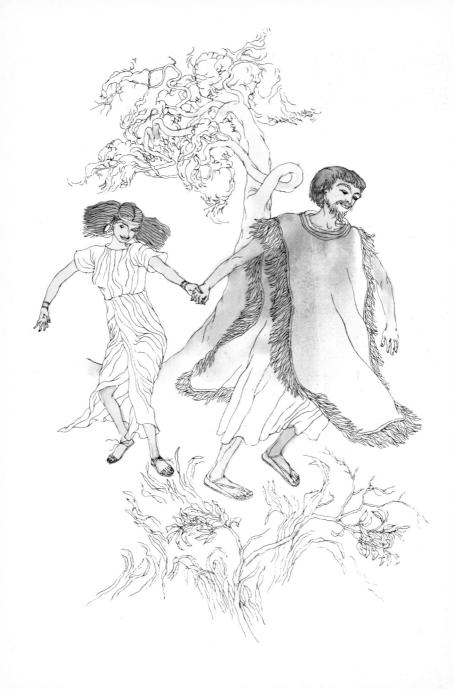

11

Come, my beloved, let us go forth into the field; let us lodge in the villages.

12

Let us get up early to the vineyards; let us see if the vine flourish, whether the tender grape appear, and the pomegranates bud forth: there will I give thee my loves.

The mandrakes give a smell, and at our gates *are* all manner of pleasant *fruits*, new and old, *which* I have laid up for thee,

O my beloved.

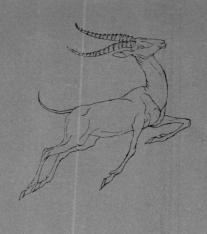

CHAPTER 8
The Return to Lebanon

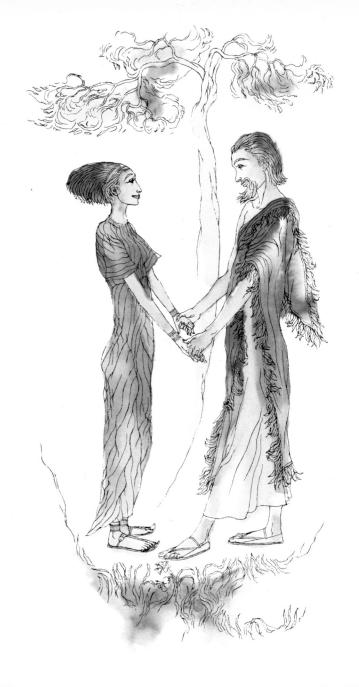

O that thou wert as my brother, that sucked the breasts of my mother! when I should find thee without, I would kiss thee; yea, I should not be despised.

2

I would lead thee,

and bring thee into my mother's house,

who would instruct me:

I would cause thee to drink of spiced wine

of the juice of my pomegranate.

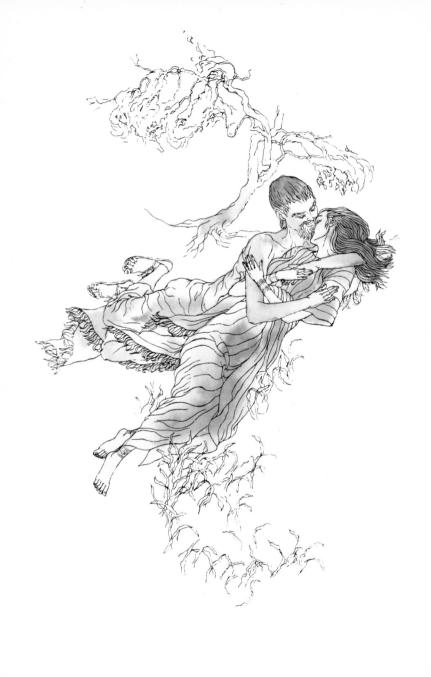

3

His left hand should be under my head, and his right hand should embrace me.

4

I charge you, O daughters of Jerusalem, that ye stir not up, nor awake *my* love, until he please.

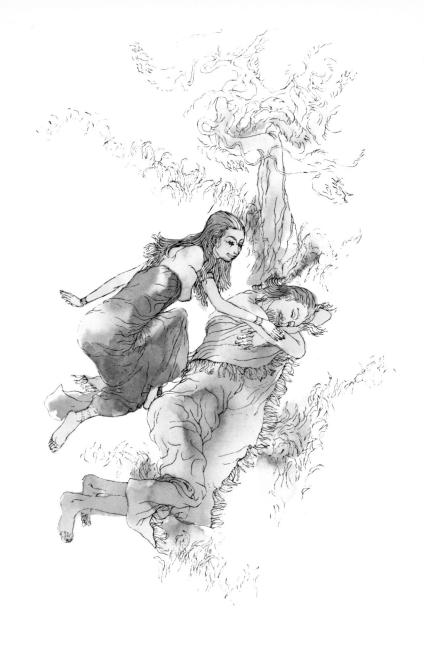

Who is this that cometh up from the wilderness, leaning upon her beloved?

I raised thee up under the apple tree: there thy mother brought thee forth: there she brought thee forth that bare thee.

Set me as a seal upon thine heart, as a seal upon thine arm: for love *is* strong as death; jealousy *is* cruel as the grave: the coals thereof *are* coals of fire, which hath a most vehement flame.

Many waters cannot quench love, neither can the floods drown it: if a man would give all the substance of his house for love, it would utterly be contemned.

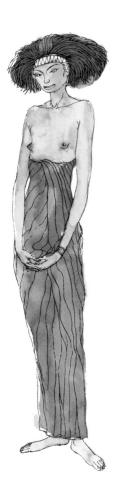

We have a little sister, and she hath no breasts: what shall we do for our sister in the day when she shall be spoken for?

9

If she *be* a wall, we will build upon her a palace of silver: and if she *be* a door, we will inclose her with boards of cedar.

10

I am a wall, and my breasts like towers: then was I in his eyes as one that found favour.

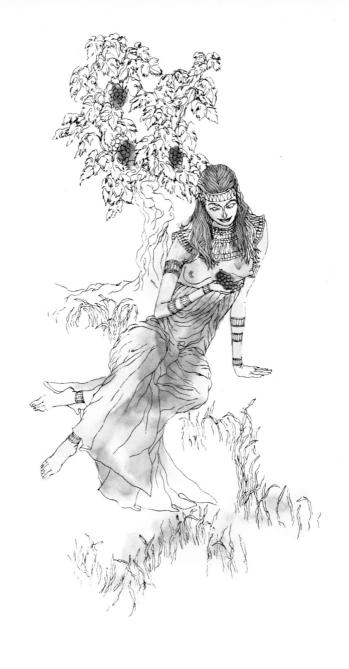

Solomon had a vineyard at Baalhamon; he let out the vineyard unto keepers; every one for the fruit thereof was to bring a thousand *pieces* of silver.

12

My vineyard, which *is* mine, *is* before me: thou, O Solomon, *must* have a thousand, and those that keep the fruit thereof two hundred.

13

Thou that dwellest in the gardens, the companions hearken to thy voice: cause me to hear *it*.

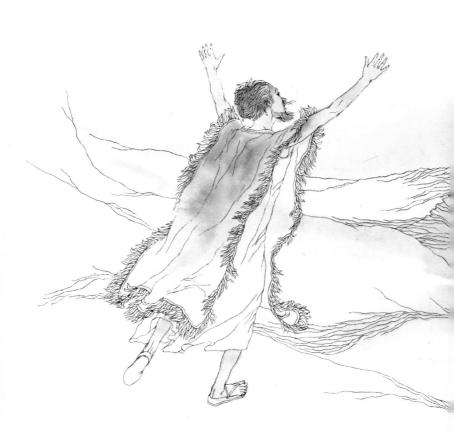

Make haste, my beloved, and be thou like to a roe or to a young hart upon the mountains of spices.

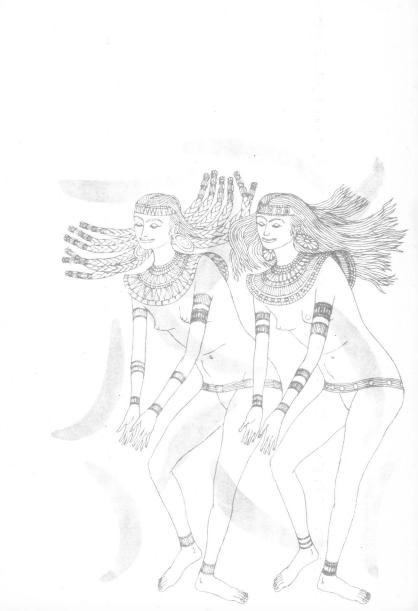

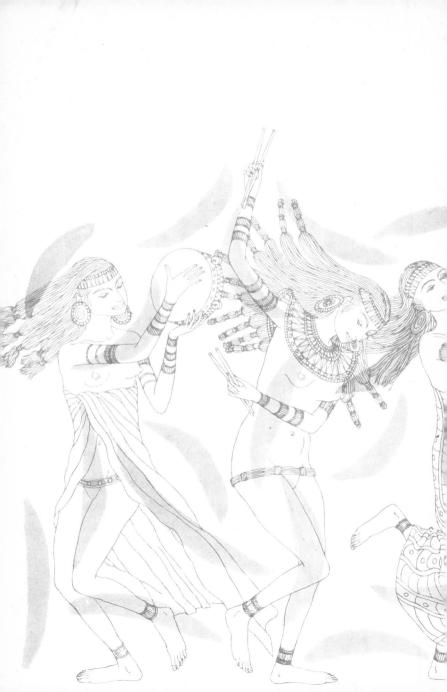